ch

National
Gallery

YPSILANTI
DISTRICT LIBRARY

37101930548972

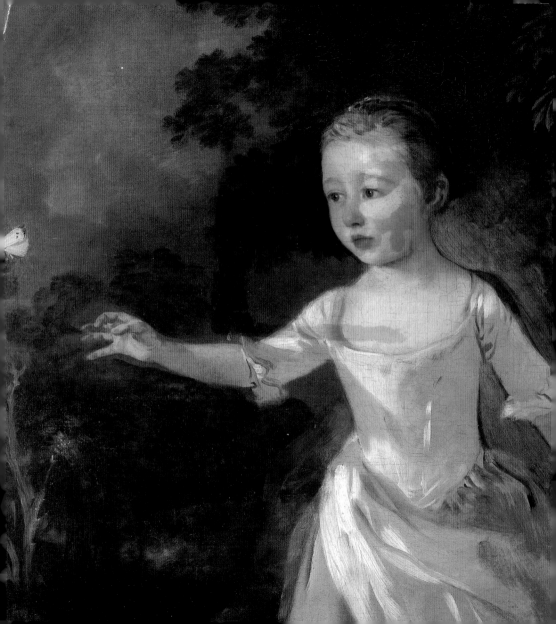

children in

art

National
Gallery

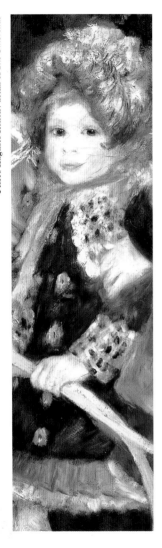

Pierre-Auguste Renoir: detail of *The Umbrellas*

First published in the United States in 1999 by
Watson-Guptill Publications, a division of BPI Communications, Inc.,
1515 Broadway, New York, NY 10036

Series Editor: Ljiljana Ortolja-Baird
Designer: Susannah Good
Design concept: Bet Ayer

Library of Congress Catalog Card Number : 99–63667

ISBN: 0 8230 0338 8

Published in the United Kingdom in 1999 by
MQ Publications Ltd., 254–258 Goswell Road,
London EC1V 7RL, in association with The National Gallery
Company Ltd., London.

Printed and bound in China

1 2 3 4 5 6 7 8 / 06 05 04 03 02 01 00 99

Title page: Thomas Gainsborough, detail of *The Painter's Daughters
chasing a Butterfly*

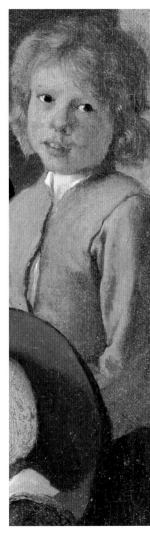

Jan Steen: detail of *A Peasant Family at Meal-time*

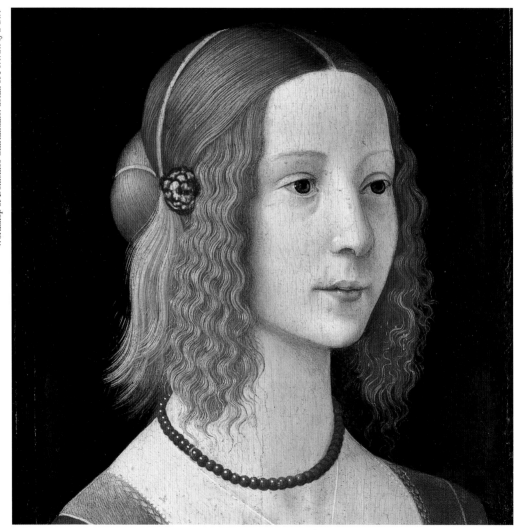

INTRODUCTION

"As painting, so poetry." Like all siblings, the Sister Arts are rivals and allies. In the mirrors they hold up to nature we see ourselves reflected from varying angles and by different lights.

The National Gallery in London houses many of the world's most famous paintings. Some celebrate the joys of childhood, recording children at play, at school, at rest, and within the intimacy of family relationships.

Wittily juxtaposing texts and images, this book allows us to eavesdrop on past conversations—between school friends, warring siblings, a boy and his horse, a girl and her pet kitten, a mother and her baby—while simultaneously evoking our own childhood.

By exploring the paintings in detail, we frequently discover aspects we never "knew" were there, and by pairing text and image, *Children in Art* enhances the descriptive powers of both painting and literature, encouraging us to hone our responses to each.

Erika Langmuir
Head of Education, National Gallery, 1988–1995

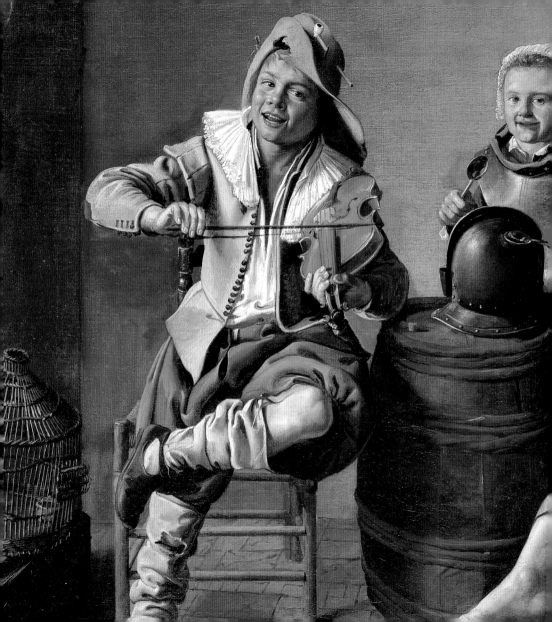

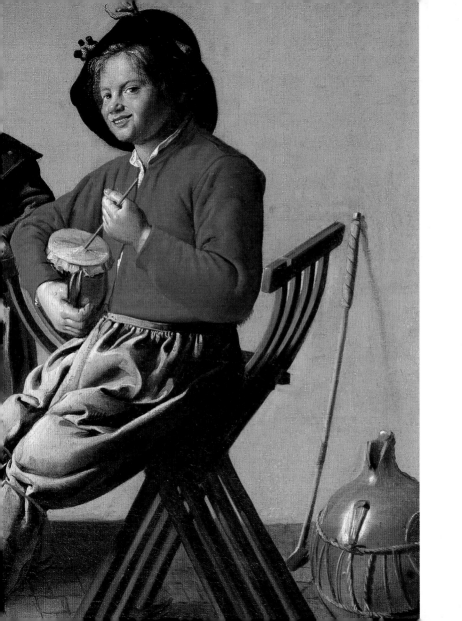

play

JOHN CONSTABLE (1776–1837) English
The Cornfield
1826

There was a child went forth every day,
And the first object he look'd upon, that object he became,
And that object became part of him for the day or a certain
 part of the day,
Or for many years or stretching cycles of years.

The early lilacs became part of this child,
And grass and white and red morning-glories, and white and
 red clover, and the song of the phoebe-bird,
And the Third-month lambs and the sow's pink-faint litter,
 and the mare's foal and the cow's calf,
And the noisy brood of the barnyard or by the mire of the
 pond-side,
And the fish suspending themselves so curiously below there,
 and the beautiful curious liquid,
And the water-plants, with their graceful flat heads, all
 became part of him.

from *There was a Child went Forth*
WALT WHITMAN, 1871

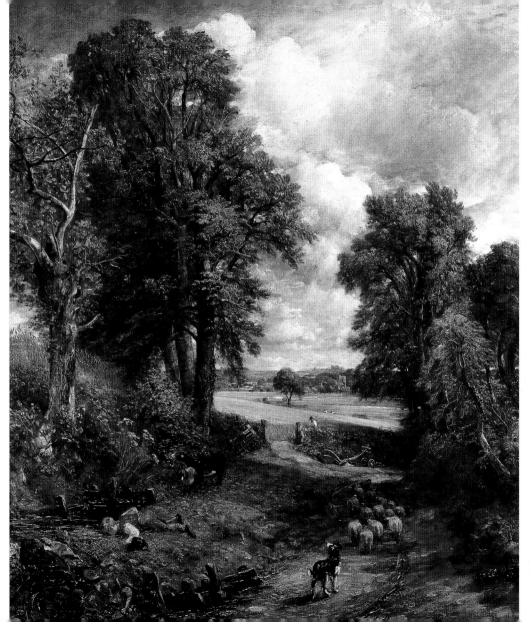

11

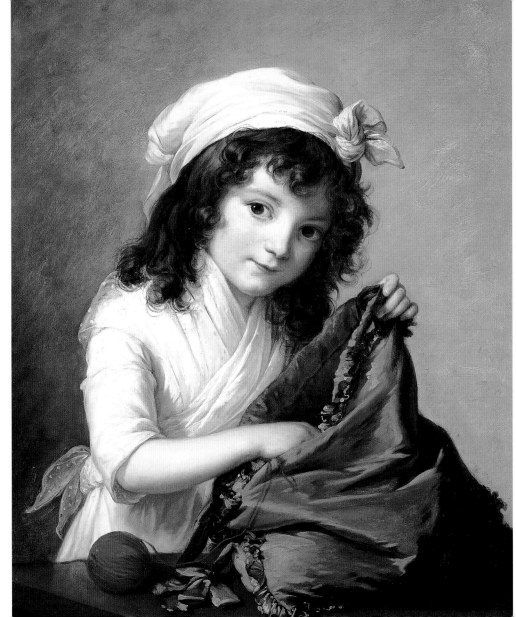

14

ELIZABETH LOUISE VIGÉE LE BRUN (1755–1842)

French

Mademoiselle Brongniart

1788

Miss Agnes had two or three dolls, and a box
To hold all their bonnets, and tippets, and frocks.
In a red leather thread case, that snapped when it shut
She had needles to sew with, and scissors to cut:
But Agnes lik'd better to play with rude boys
Than work with her needle, or play with her toys;
Young ladies should always appear neat and clean,
Yet Agnes was seldom drest fit to be seen.
I saw her one day attempting to throw
A very large stone when it fell on her toe,
The boys who were present, and saw what was done,
Set up a loud laugh, and call'd it fine fun.
But I took her home, and the doctor soon came,
And Agnes I fear will a long time be lame,
And from morning till night she laments very much,
That now when she walks she must lean on a crutch,
And she has told her dear father a thousand times o'er,
That she never will play with rude boys any more.

The Hoyden, A Cautionary Tale
ANONYMOUS, 1811

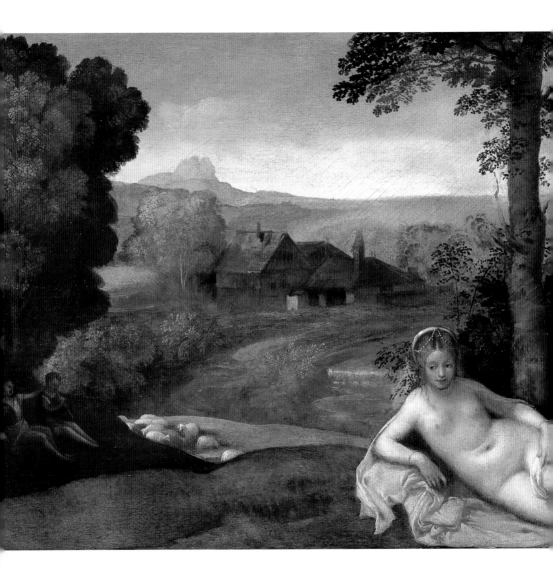

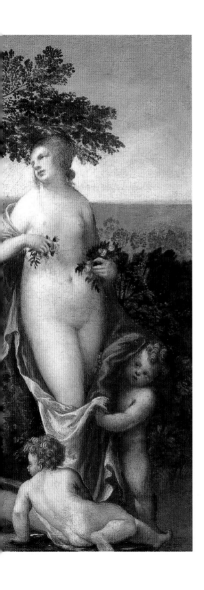

IMITATOR OF GIORGIONE
Italian
Nymphs and Children in a Landscape with Shepherds
probably 1575–1625

When the voices of children are heard on the green
And laughing is heard on the hill,
My heart is at rest within my breast
And everything else is still

Then come home my children, the sun is gone down
And the dews of the night arise
Come come leave off play, and let us away
Till the morning appears in the skies

No no let us play, for it is yet day
And we cannot go to sleep
Besides in the sky, the little birds fly
And the hills are all covered with sheep

Well well go and play till the light fades away
And then go to bed
The little ones leaped and shouted and laugh'd
And all the hills echoed.

Nurse's Song
WILLIAM BLAKE, 1789

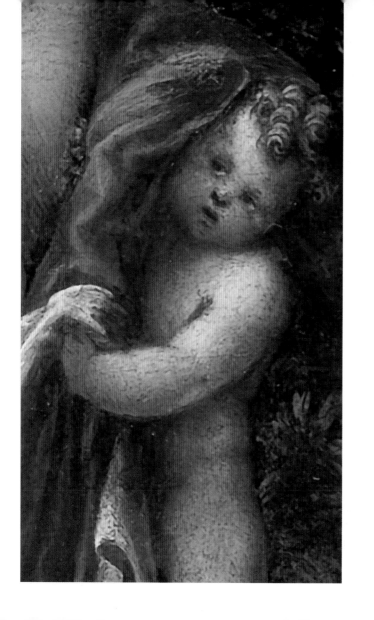

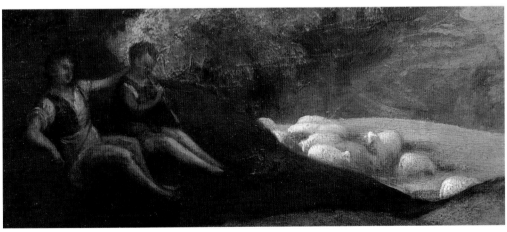

FLEMISH

Portrait of a Boy holding a Rose

about 1600

My parents kept me from children who were rough
Who threw words like stones and who wore torn clothes.
Their thighs showed through rags. They ran in the street
And climbed cliffs and stripped by the country streams.

I feared more than tigers their muscles like iron
Their jerking hands and their knees tight on my arms.
I feared the salt coarse pointing of those boys
Who copied my lisp behind me on the road.

They were lithe, they sprang out behind hedges
Like dogs to bark at my world. They threw mud
While I looked the other way, pretending to smile.
I longed to forgive them, but they never smiled.

Rough
STEPHEN SPENDER, 1933

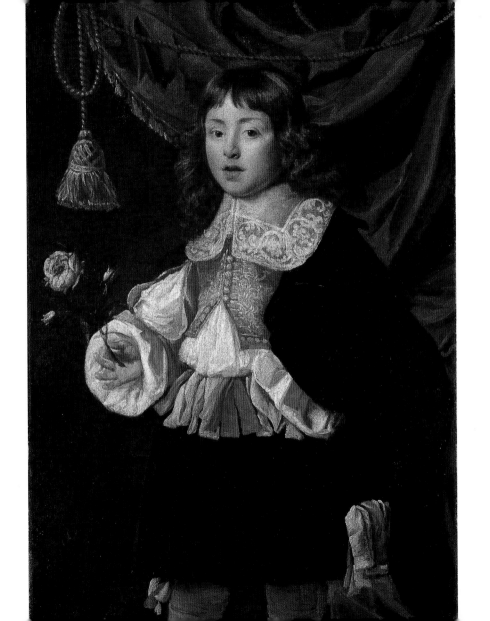

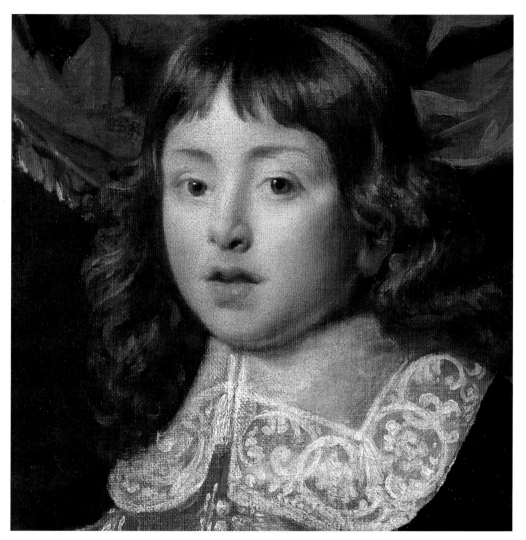

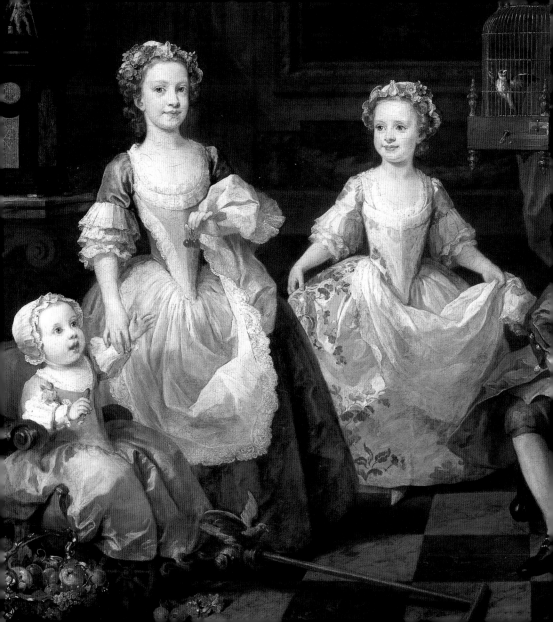

WILLIAM HOGARTH (1697–1764) English
The Graham Children
1742

We live in our world,
A world that is too small
For you to stoop and enter
Even on hands and knees,
The adult subterfuge.
And though you probe and pry
With analytic eye,
And eavesdrop all our talk
With an amused look,
You cannot find the centre
Where we dance, where we play,
Where life is still asleep
Under the closed flower,
Under the smooth shell
Of eggs in the cupped nest
That mock the faded blue
Of your remoter heaven.

Children's Song
R. S. THOMAS, 1955

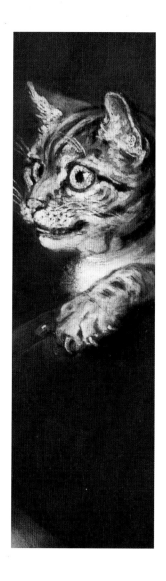

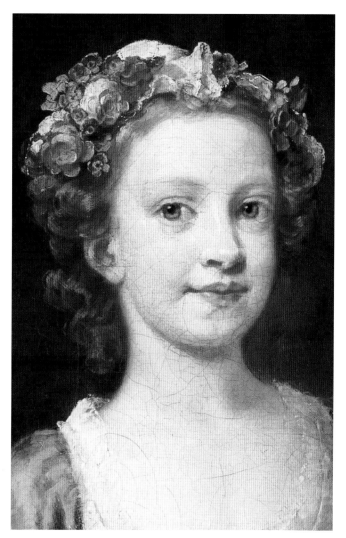

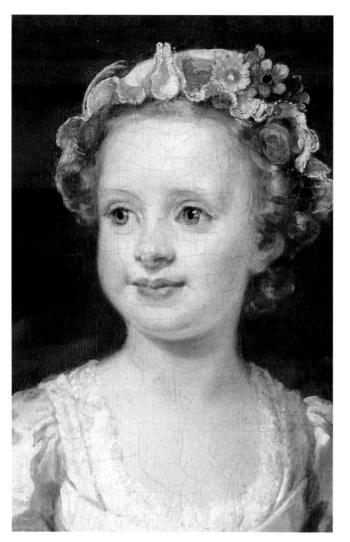

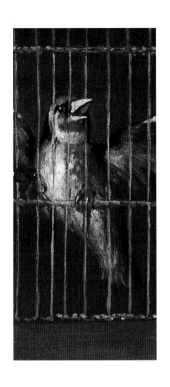

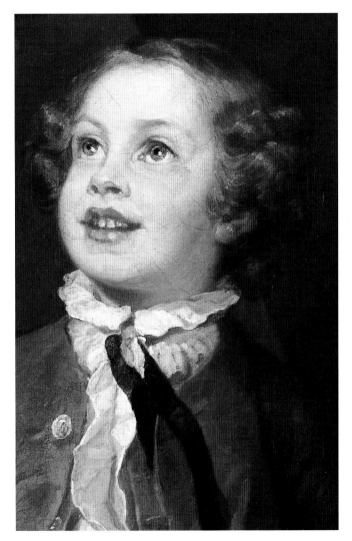

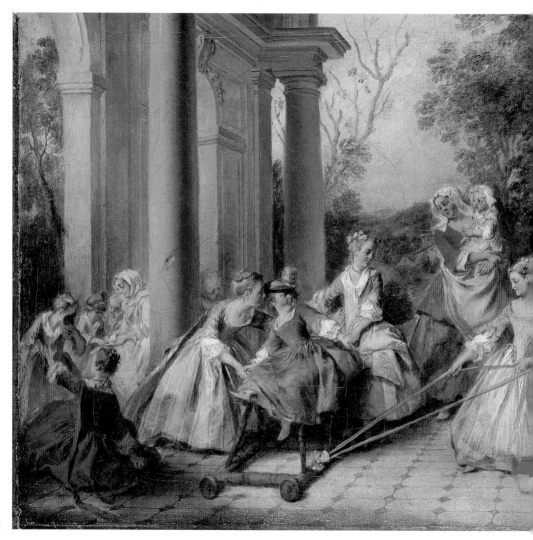

NICOLAS LANCRET (1690–1743) French
The Four Ages of Man: Childhood
1730–35

May I join you in the doghouse, Rover?
I wish to retire till the party's over.
Since three o'clock I've done my best
To entertain each tiny guest;
My conscience now I've left behind me,
And if they want me, let them find me.
I blew their bubbles, I sailed their boats
I kept them from each other's throats.
I told them tales of magic lands,
I took them out to wash their hands.
I sorted their rubbers and tied their laces,
I wiped their noses and dried their faces.
Of similarity there's lots
Twixt tiny tots and Hottentots.
I've earned repose to heal the ravages
Of these angelic-looking savages.
Oh, progeny playing by itself
Is a lonely fascinating elf,
But progeny in roistering batches
Would drive St. Francis from here to Natchez.
Shunned are the games a parent proposes;
They prefer to squirt each other with hoses,
Their playmates are their natural foemen
And they like to poke each other's abdomen.

34

Their joy needs another's woe to cushion it,
Say a puddle, and somebody littler to push
 in it.
They observe with glee the ballistic results
Of ice cream with spoons for catapults,
And inform the assembly with tears and glares
That everyone's presents are better than theirs.
Oh, little women and little men,
Someday I hope to love you again,
But not till after the party's over,
So give me the key to the doghouse, Rover.

Children's Party
OGDEN NASH, 1936

PIERRE-AUGUSTE RENOIR (1841–1919)
French
The Umbrellas
about 1881–86

Time like a morning hoop will roll from
Christmas time to New Year's Day...
And guide to its appointed goal the cyclic
 pageantry of play.

Time Like a Morning Hoop
ANONYMOUS, 19th century

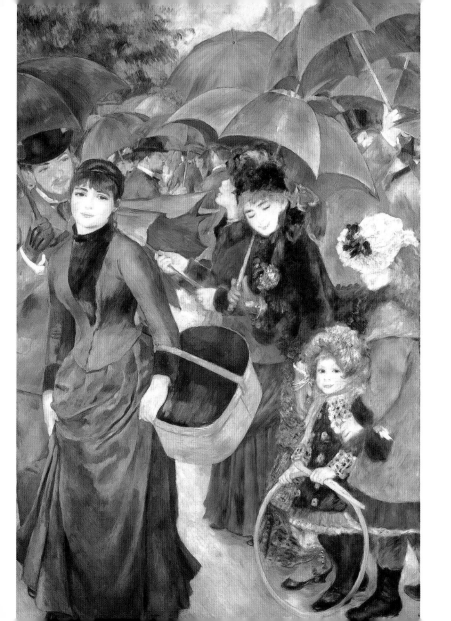

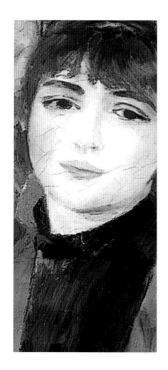

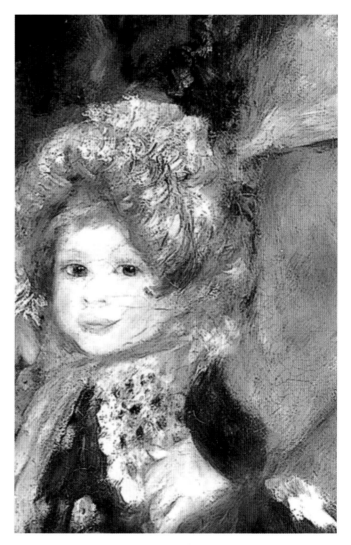

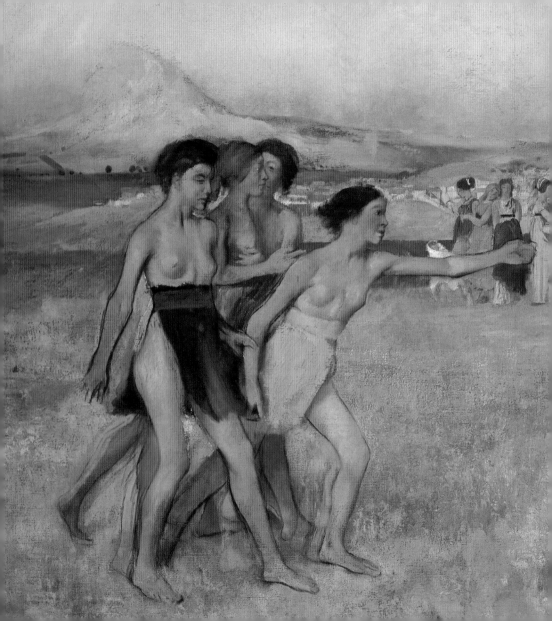

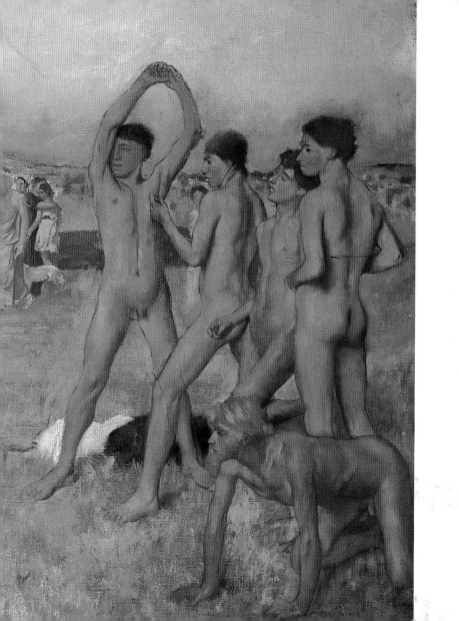

School

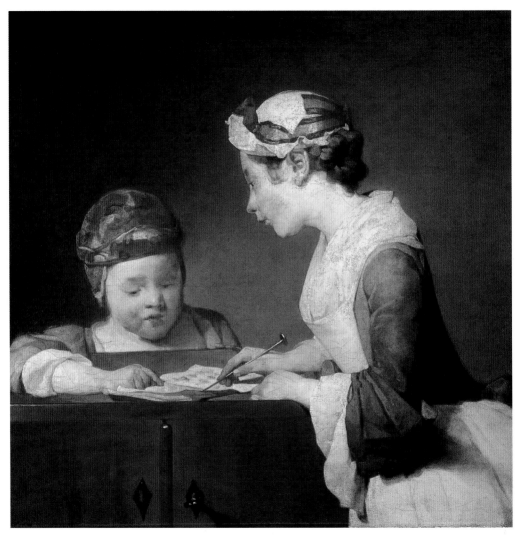

42

JEAN-SIMÉON CHARDIN (1699–1779) French
The Young Schoolmistress
probably 1735–36

'Can you do Addition?' the White Queen asked. 'What's one and one and one and one and one and one and one and one and one?'

'I don't know,' said Alice. 'I lost count.'

'She can't do Addition,' the Red Queen interrupted. 'Can you do subtraction? Take nine from eight.'

'Nine from eight I can't, you know,' Alice replied readily: 'but—

'She can't do Subtraction,' said the White Queen. 'Can you do Division? Divide a loaf by a knife—what's the answer to that?'

from *Through the Looking Glass*
LEWIS CARROLL, 1872

ITALIAN, Neapolitan
Christ Disputing with the Doctors
1675–1700

The wise Zacharias said
 'This lad is wonderful
And he'd be a hundred times better
 If he went to school.'

Jesus went with Zacharias
 Who wished to teach him to read;
'Here's the alphabet, boy. Say A.'
 The all-knowing head

Refused. Zacharias used the stick.
 Jesus then said
'Strike an anvil, what is the lesson?
 The anvil teaches the man.'

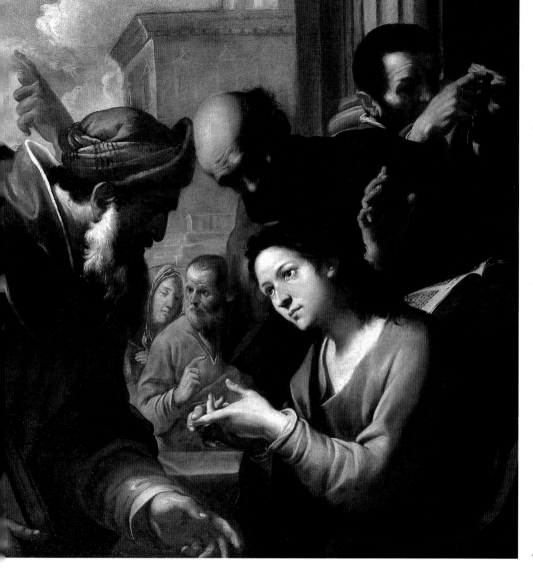

Quietly then the boy
 Proved that his words were true,
Speaking to old Zacharias
 More than Zacharias knew.

Said the wise Zacharias then
 'Take the boy from me now
I can't give any answer,
 Leave me with what I know.'

Jesus at School
BRENDAN KENNELLY, pub. 1970

NICOLAS-TOUSSAINT CHARLET (1792–1845) French
Children at a Church Door
about 1817–45

'Twas on Holy Thursday their innocent faces clean
The children walking two and two in red and blue and green
Grey-headed beadles walked before with wands as white as
 snow
Till into the high dome of Paul's they like Thames water
 flow
O what a multitude they seemed these flowers of London
 town
Seated in companies they sit with radiance all their own
The hum of multitudes was there but multitudes of lambs
Thousands of little boys and girls raising their innocent
 hands

Now like a mighty wind they raise to heaven the voice of
 song
Or like harmonious thunderings the seats of heaven among
Beneath them sit the aged men wise guardians of the poor
Then cherish pity; lest you drive an angel from your door.

<div align="right">

Holy Thursday
WILLIAM BLAKE, 1789

</div>

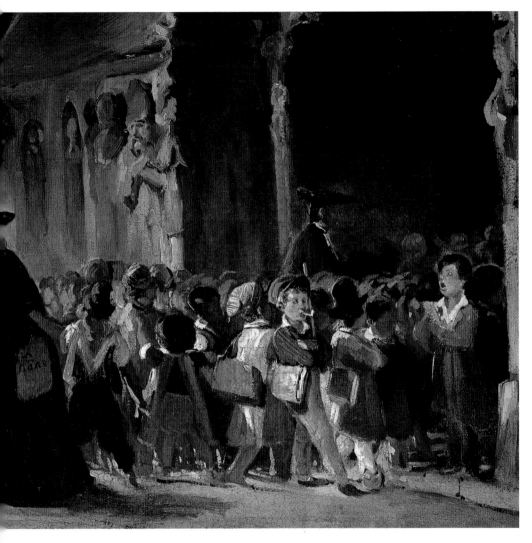

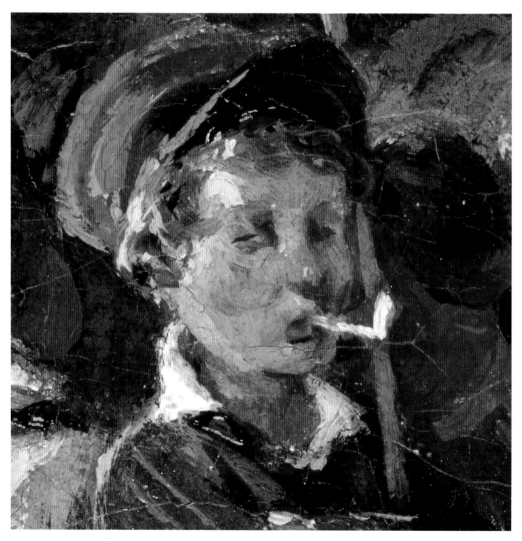

54

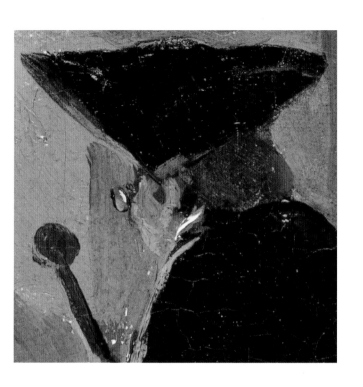

STANISLAS-VICTOR-EDMOND LÉPINE (1835–1892)
French
Nuns and Schoolgirls in the Tuileries Gardens, Paris
1871–83

We skipped our way to school along the rough grassy land,
through the wood and along the sloping field paths. It was
a quick way of getting anywhere, it gave wings to our feet.
We skipped in the playground with one big rope where
the pupil teachers turned and forty little and big girls in
a long procession danced their way through 'Keep the Pot
a-boiling'…

from *Country Things*
ALISON UTTLEY, 1946

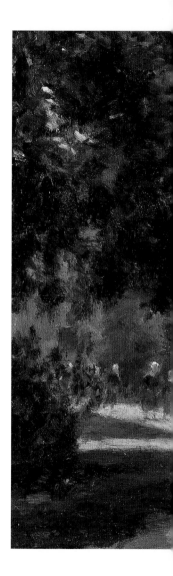

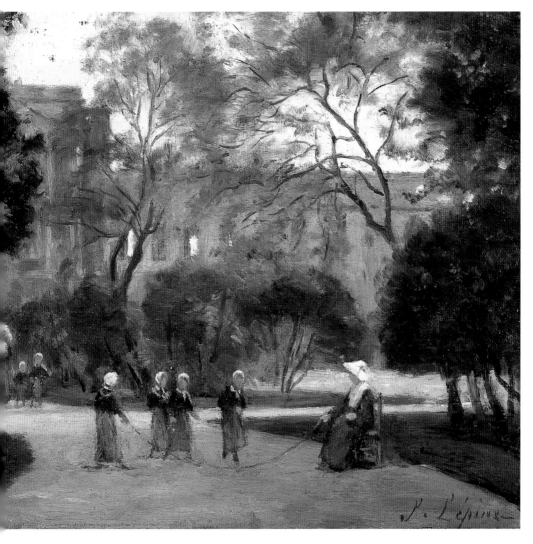

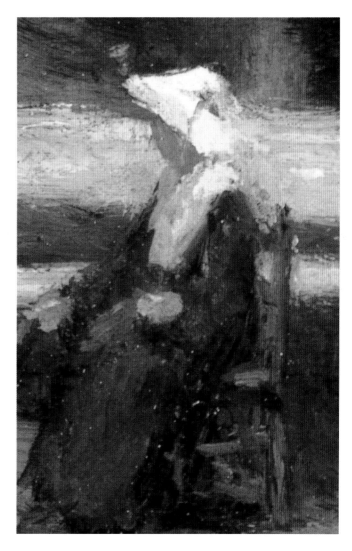

59

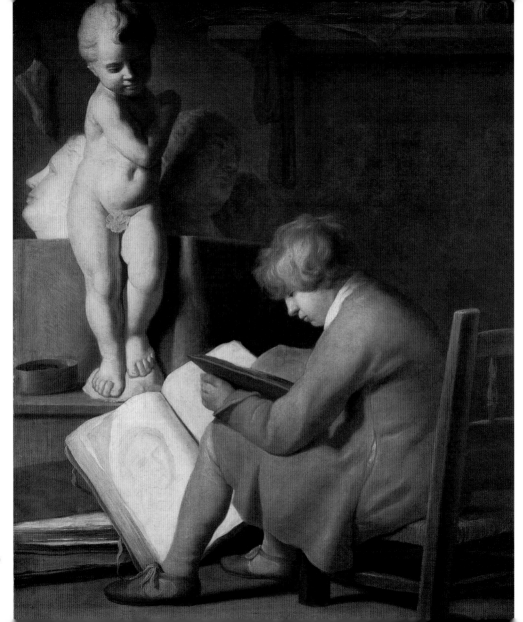

After Wallerant Vaillant (1623–1677) Dutch
A Boy seated Drawing
18th century

A rather solitary boy—
we were hardly aware of him until
one day, when we were in 5C,
in Assembly, as the Assistant Head
was intoning the Lord's Prayer, he sang

> If you go down to the woods today
> You'd better not go alone,
> It's lovely down in the woods today
> But safer to stay at home

loud and was removed during the second verse.

About a week later, in Chemistry,
Mr Watts discovered him writing up
his account of the preparation of
sodium thiosulphate crystals
in an unusual manner i.e.
he would do a few lines and then invert
his exercise book before scrawling
the next bit—alternate paragraphs
upside-down. When asked why, he replied
'In Japan the natives eat fish raw.'

from *Alma Mater*
PETER READING, 1981

CASPAR NETSCHER (1635/36?–1684) Dutch
A Lady Teaching a Child to read, and a Child
playing with a Dog ('La Maîtresse d'école')
probably 1670s

A worm ate words. I thought that wonderfully
Strange—a miracle—when they told me a crawling
Insect had swallowed noble songs,
A night-time thief had stolen writings
So famous, so weighty. But the bug was foolish
Still, though its belly was full of thought.

Bookworm
ANONYMOUS, 10th century

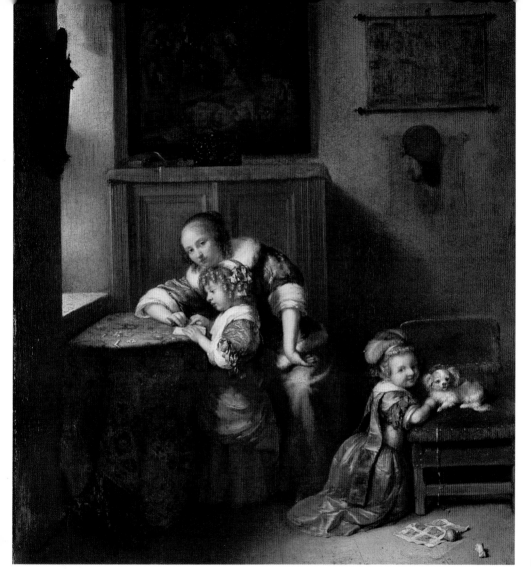

67

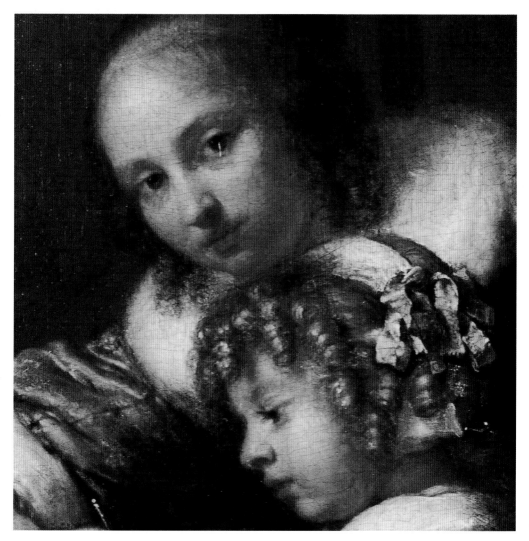

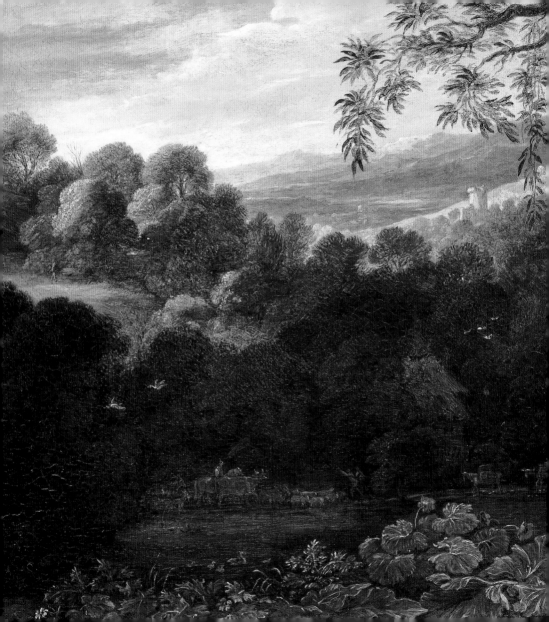

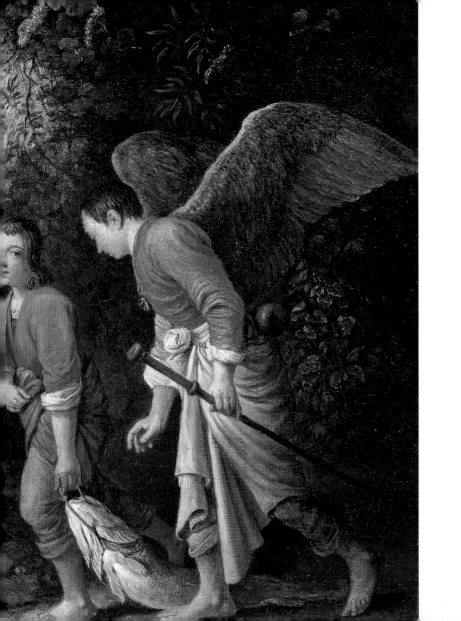

friends

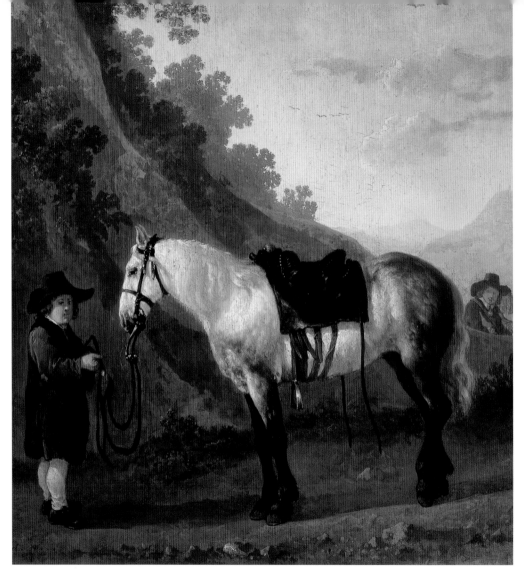

Attributed to ABRAHAM VAN CALRAET
(1642–1722) Dutch
A Boy holding a Grey Horse
probably 1670–1722

He put out his hand and gave me a kind pat on
the neck. I put out my nose in answer to his kind-
ness; the boy stroked my face.

'Poor old fellow! See, Grandpa, how well he
understands kindness. Could you not buy him and
make him young again, as you did with
Ladybird?'
…''Tis speculation,' said the old gentleman, shak-
ing his head, but at the same time slowly drawing
out his purse—'quite speculation!'
…'You,Willie,' said he, 'must take the oversight of
him; I give him in charge to you.'

The boy was proud of his charge, and under-
took it in all seriousness. There was not a day
when he did not pay me a visit, sometimes picking
me out amongst the other horses, and giving me a
bit of carrot, or something good, or sometimes
standing by me whilst I ate my oats. He always
came with kind words and caresses, and of course
I grew very fond of him. He called me Old Crony,
as I used to come to him in the field and follow
him about.

from *Black Beauty*
ANNA SEWELL, 1877

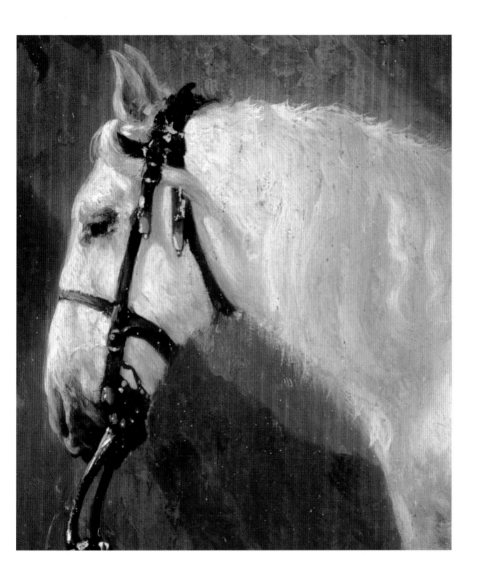

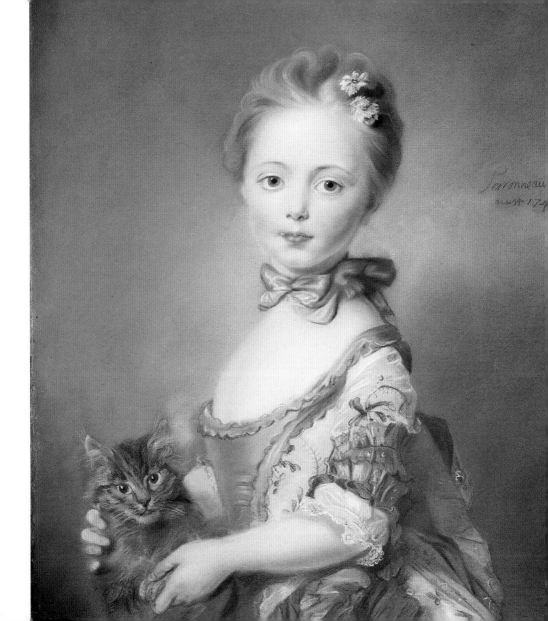

JEAN-BAPTISTE PERRONNEAU (1715?–1783) French
A Girl with a Kitten
1745

I like little pussy, her coat is so warm;
And if I don't hurt her, she'll do me no harm.
So I'll not pull her tail, nor drive her away,
But pussy and I very gently will play.
She shall sit by my side, and I'll give her some food;
And she'll love me because I am gentle and good.

I'll pat pretty pussy, and then she will purr;
And thus show her thanks for my kindness to her.
But I'll not pinch her ears, nor tread on her paw,
Lest I should provoke her to use her sharp claw.
I never will vex her, nor make her displeased—
For pussy don't like to be worried and teased.

Pussy
ANONYMOUS, C.1830

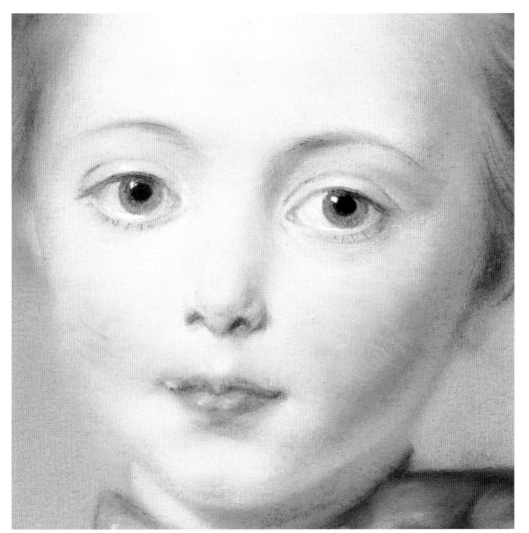

THOMAS GAINSBOROUGH (1727–1788) English
The Painter's Daughters with a Cat
about 1760–61

We talked as Girls do—
Fond, and late—
We speculated fair, on every subject,
 but the Grave—
Of ours, none affair—

We handled Destinies, as cool—
As we—Disposers—be
And God, a Quiet Party
To our Authority—

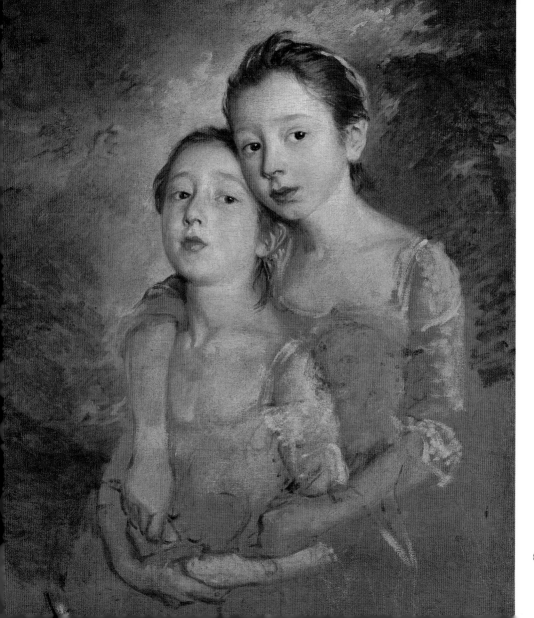

But fondest, dwelt upon
 Ourself
As we eventual—be—
When Girls to Women, softly
 raised
We—occupy—Degree—

We parted with a contract
To cherish, and to write
But Heaven made both,
 impossible
Before another night.

We Talked as Girls Do
EMILY DICKINSON, c.1862

NICOLAES MAES (1634–1693) Dutch
Christ blessing the Children
1652–53

Hadst Thou ever any toys,
Like us little girls and boys?
And didst Thou play in Heaven with all
The angels, that were not too tall,
With stars for marbles? Did the things
Play 'Can you see me?' through their wings?

Didst Thou kneel at night to pray,
And didst Thou join Thy hands, this way?
And did they tire sometimes, being young,
And make the prayer seem very long?
And dost Thou like it best, that we
Should join our hands to pray to Thee?

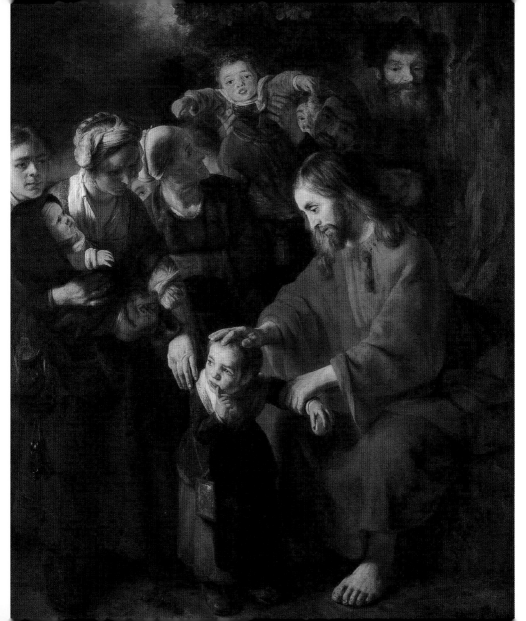

I used to think before I knew,
The prayer not said unless we do.
And did Thy Mother at the night
Kiss Thee, and fold the clothes in right?
And didst Thou feel quite good in bed,
Kissed, and sweet, and Thy prayers said?

Thou canst not have forgotten all
That it feels like to be small:
And Thou know'st I cannot pray
To Thee in my father's way—
When Thou wast so little, say,
Couldst Thou talk Thy Father's way?—

So, a little Child, come down
And hear a child's tongue like Thy own;
Take me by the hand and walk,
And listen to my baby-talk.
To Thy Father show my prayer
(He will look, Thou art so fair),
And say: 'Oh Father, I, Thy Son,
Bring the prayer of a little one.'

And He will smile, that children's tongue
Hast not changed since Thou wast young!

from *Ex Ore Infantium*
FRANCIS THOMPSON, 1893

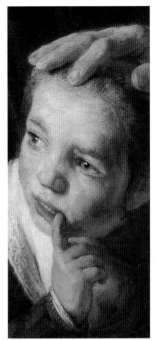

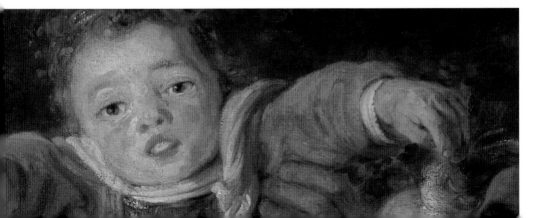

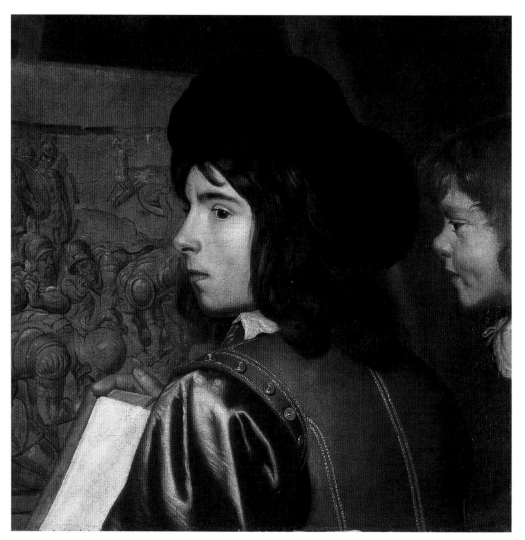

Attributed to JACOB VAN OOST THE ELDER
(1601–1671) Flemish
Two Boys before an Easel
about 1645

The first day he attended Tiberi Avila's anatomy class, he
found himself sitting next to a second-year student, Manuel
Pallarès i Grau, a farmer's son from a remote village in the
mountains of southern Catalonia. Although Pallarès was
nineteen—almost six years older than Pablo—the two
students became instant friends. Pablo's earliest portraits
of him (winter, 1895–96) reveal Pallarès to have been an
ordinary-looking, clean-cut, fair-skinned young man—more
like a student of law than an art student. Pablo was drawn
to him because he was solid and supportive, a big brother all
too willing to take him under his wing; he was also extremely
amenable: a born disciple.

from *A Life of Picasso, Volume 1: 1881–1906*
JOHN RICHARDSON, 1991

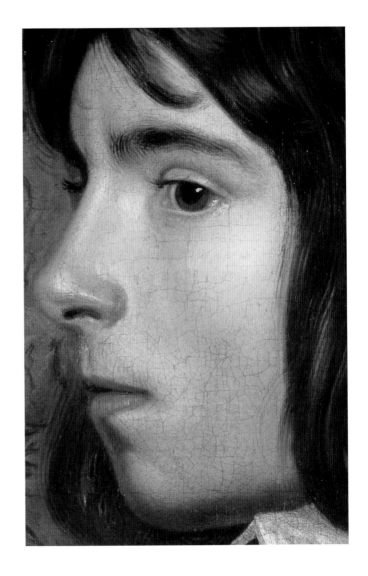

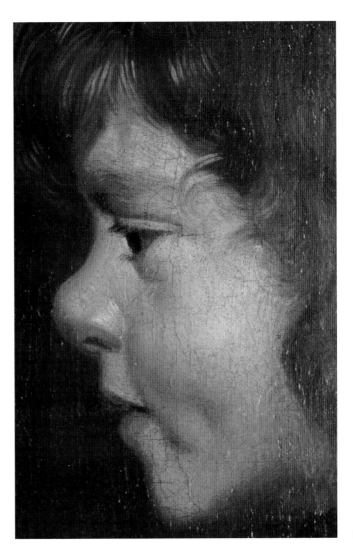

JACOB MARIS (1837–1899) Dutch
A Girl feeding a Bird in a Cage
about 1867

Mary had a little bird,
 With feathers bright and yellow
Slender legs—upon my word,
 He was a pretty fellow!

Sweetest notes he always sung,
 Which much delighted Mary;
Often where his cage was hung,
 She sat to hear Canary.

Crumbs of bread and dainty seeds
 She carried to him daily,
Seeking for the early weeds,
 She decked his palace gaily.

This, my little readers, learn,
 And ever practise duly;
Songs and smiles of love return
 To friends who love you truly.

The Canary
ELIZABETH TURNER, c. 1807

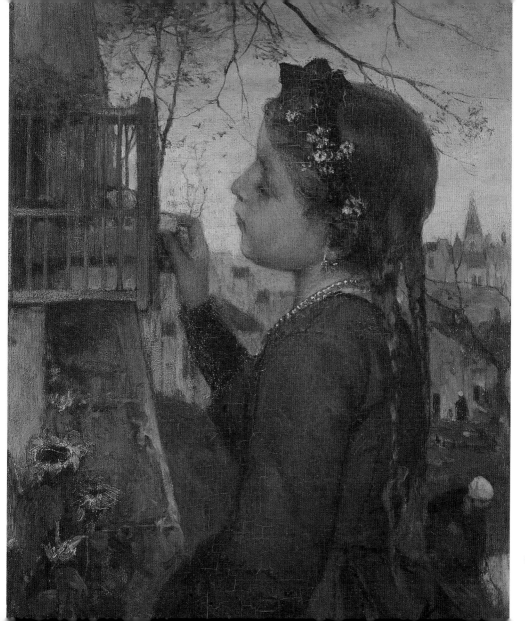

95

HILAIRE-GERMAIN-EDGAR
DEGAS
(1834–1917) French
Beach Scene
probably 1868–77

Granny Granny
please comb my hair
you always take your time
you always take such care

You put me to sit on a
 cushion
between your knees
you rub a little coconut oil
parting gentle as a breeze

Mummy Mummy
 she's always in a hurry—
hurry
rush
she pulls my hair
sometimes she tugs

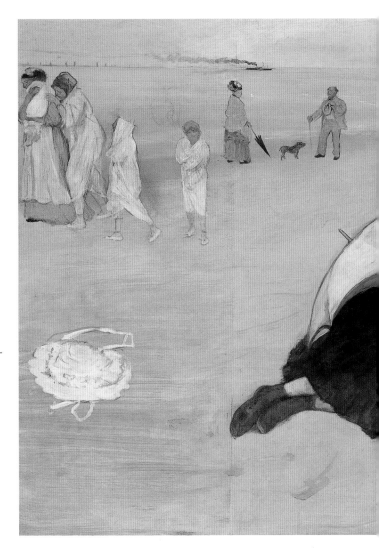

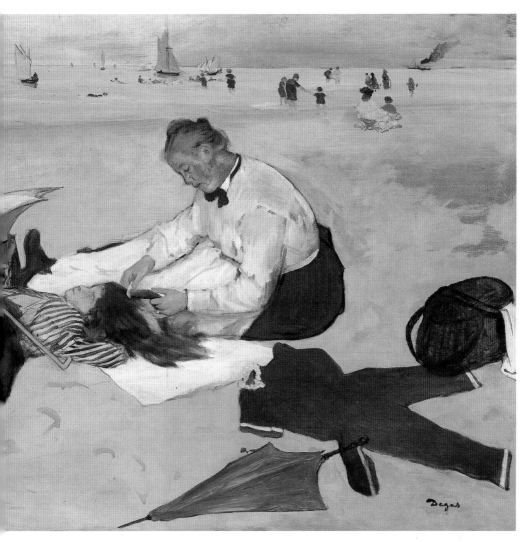

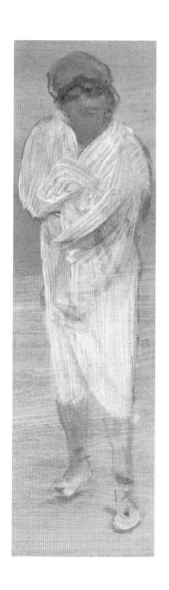

But Granny
you have all the time in
 the world
and when you've finished
you always turn my head
 and say
'Now who's a nice girl.'

Granny Granny Please Comb my Hair
GRACE NICHOLS, pub. 1988

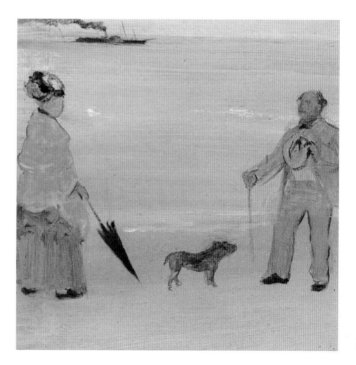

99

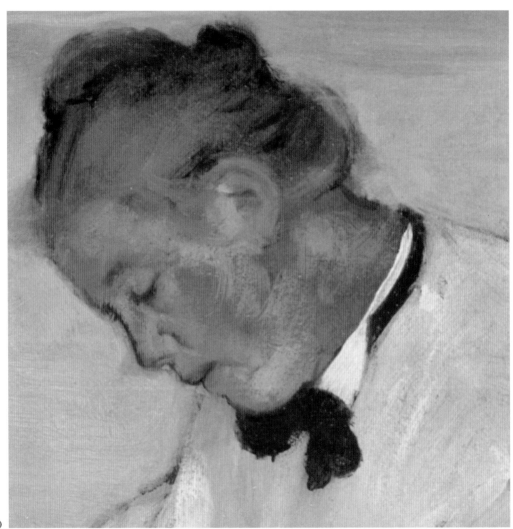

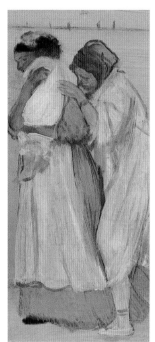

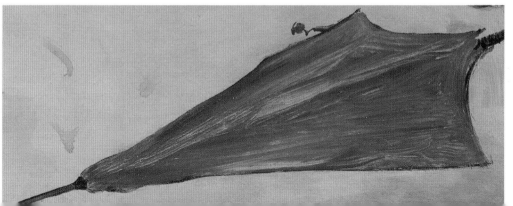

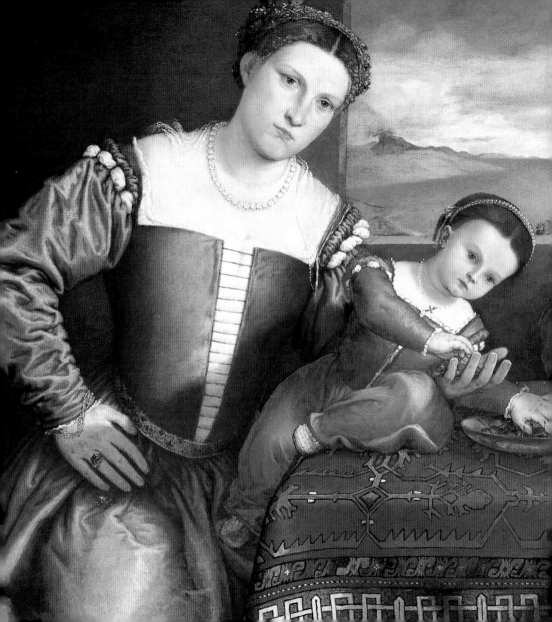

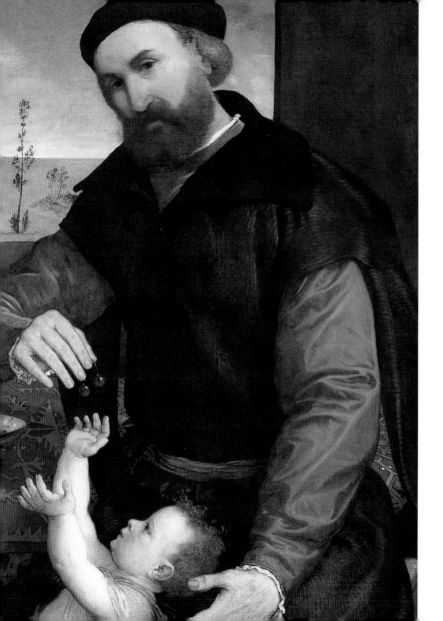

home

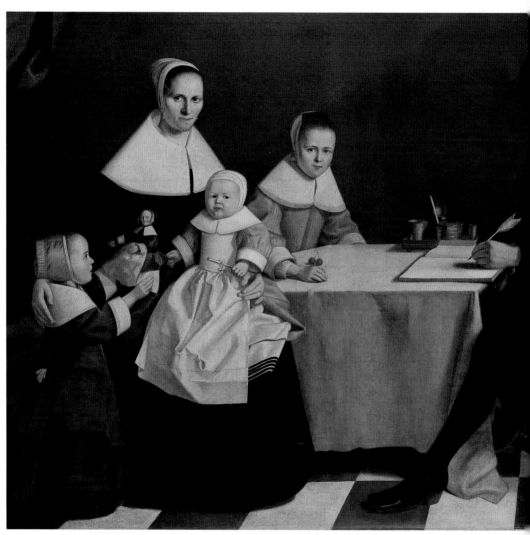

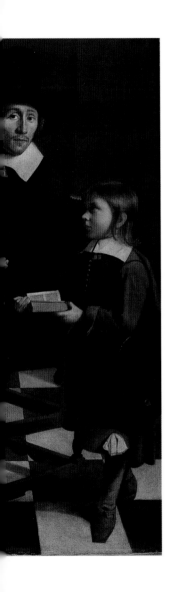

Attributed to MICHIEL NOUTS (active 1656)
A Family Group
about 1655

One of the greatest rebukes…which I can remember to have
received from my father was for my disrespect, when I was
about twelve years old, in taking from the bookshelves a
thick old Bible in order to enable me to sit more conveniently
at my dinner.

from the diaries of
COVENTRY PATMORE, c. 1860
quoted in *Early One Morning in the Spring* by
WALTER DE LA MARE, 1949

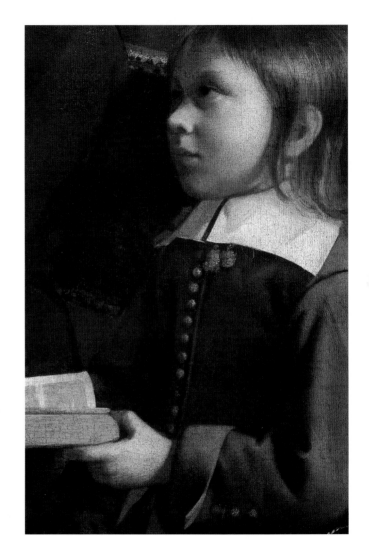

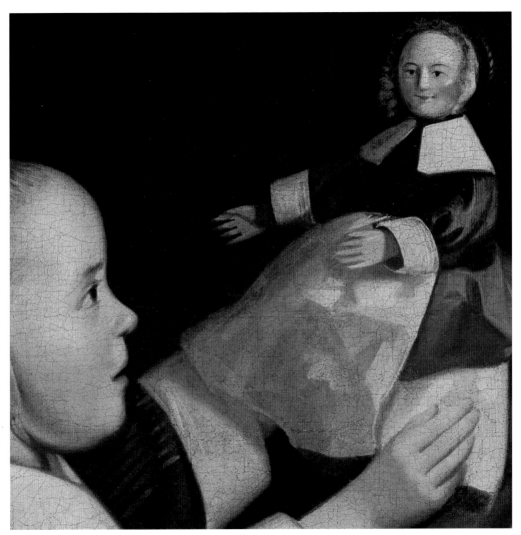

SIR JOSHUA REYNOLDS (1723–1792) English
Lady Cockburn and her Three Eldest Sons
1773

I am your laughing, crying,
possibility:
I keep on coming as
I did before,

hoping and hungering
and with no visible
means of support
whatever.

Naked need is
all I offer:
my extremity is
your opportunity,

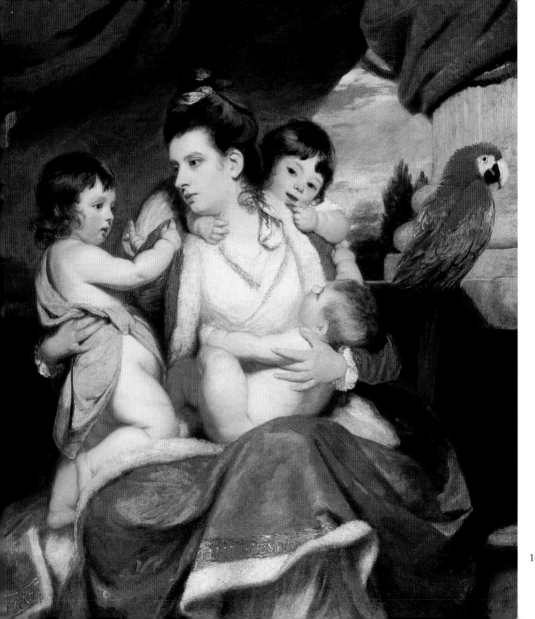

my Bethlehem
is where you can be born.
And will you be
King Herod yourself?

Look in the mirror of
my cradle, see
your laughing, crying,
possibility,

hoping and hungering
and with no visible
means of support
whatever.

Child
SYDNEY CARTER, 1969

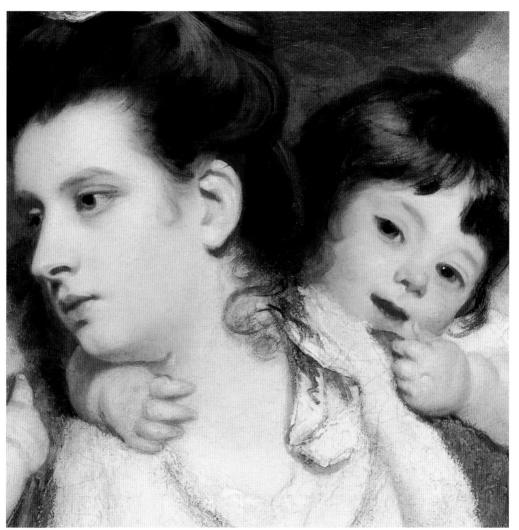

111

NICOLAES MAES (1634–1693) Dutch
A Woman scraping Parsnips, with a Child standing by her
1655

In the distance, O my lady,
 Little lady, turned of three!
Will the woodland seem as shady?
 Will the sunshine seem as free?
Will the primrose buds come peeping
 Quite as bright beneath the tree?
And the brook sing in its leaping
 As they do for you and me?

O my darling, O my daisy,
 In the days that are to be,
In the distance dim and hazy
 With its lights far out at sea;
When you're tall and fair and stately,
 Will you ever care for me?
Will you praise my coming greatly
 As you did when you were three?

In the Distance
CECIL FRANCES ALEXANDER, 1848

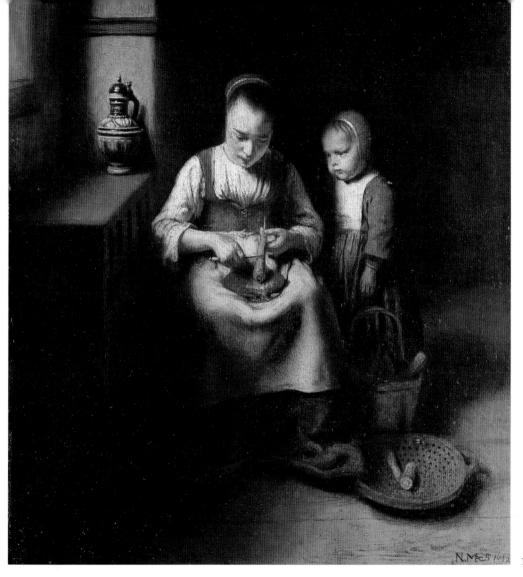

N. MAES 1655

113

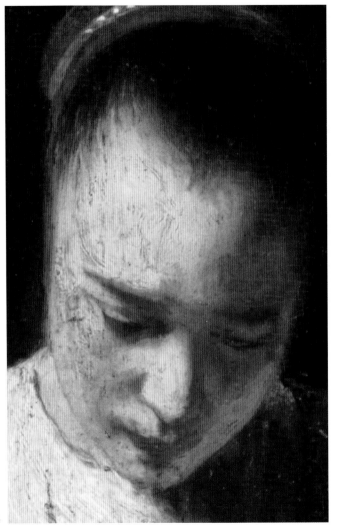

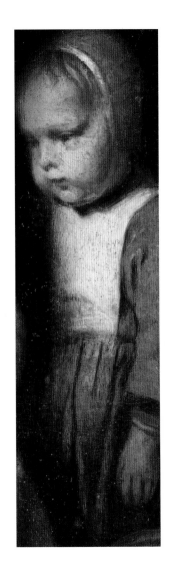

FRANS HALS (about 1580?–1666) Dutch
A Family Group in a Landscape
about 1647–50

Loving she is, and tractable, though wild;
And Innocence hath privilege in her
To dignify arch looks and laughing eyes;
And feats of cunning; and the pretty round
Of trespasses, affected to provoke
Mock-chastisement and partnership in play.
And, as a faggot sparkles on the hearth,
Not less if unattended and alone
Than when both young and old sit gathered round
And take delight in its activity;
Even so this happy Creature of herself
Is all-sufficient, solitude to her
Is blithe society, who fills the air
With gladness and involuntary songs.
Light are her sallies as the tripping fawn's
Forth-startled from the fern where she lay couched;
Unthought-of, unexpected, as the stir
Of the soft breeze ruffling the meadow-flowers,
Or from before it chasing wantonly
The many-coloured images imprest
Upon the bosom of a placid lake.

Characteristics of a Child Three Years Old
WILLIAM WORDSWORTH, 1815

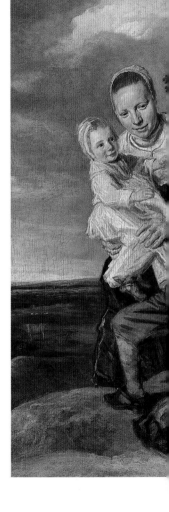

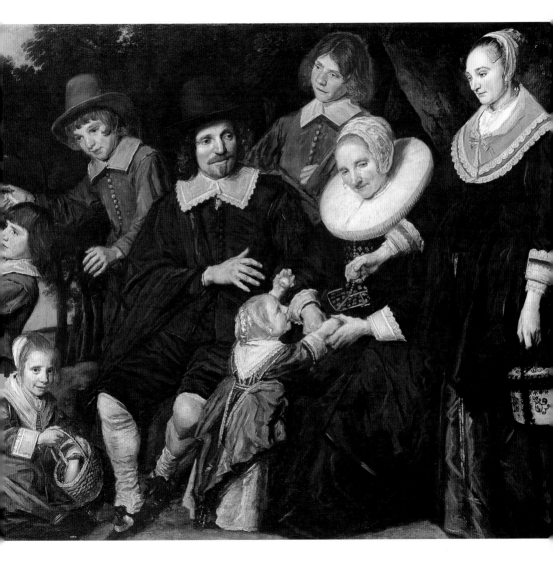

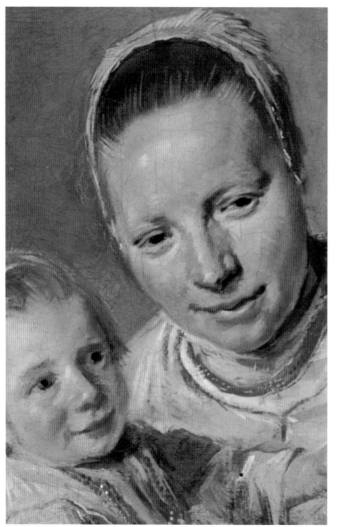

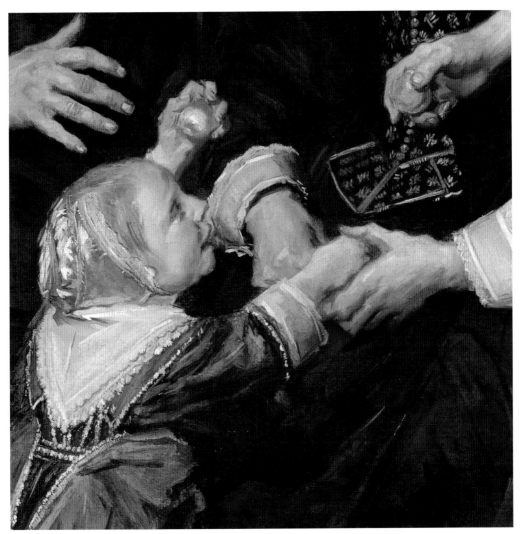

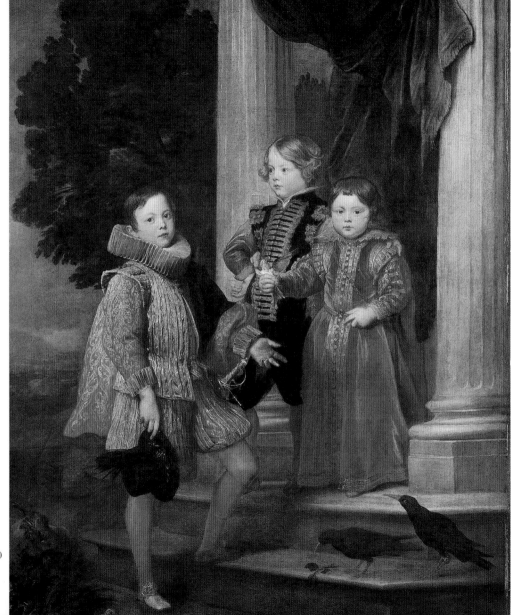

ANTHONY VAN DYCK (1599–1641) Flemish
The Balbi Children
about 1625–27

There was an old man who had three sons
And seventeen horses. 'I've written my will,'
He told his sons. 'I'm going to leave
My horses to the three of you.
But you must share them as I say.'

The old man died. The will was opened:
'To my three sons I leave
My seventeen horses.
My eldest son shall take half;
My second son shall take a third;
My youngest son shall take a ninth.
 Shed no blood,
 Do not kill;
 You must obey
 Your father's will.'

The three sons were puzzled. At school
They'd been well taught, but not so well
That they could divide
 17 by 2,
 17 by 3,
 17 by 9,
And still obey their father's will.

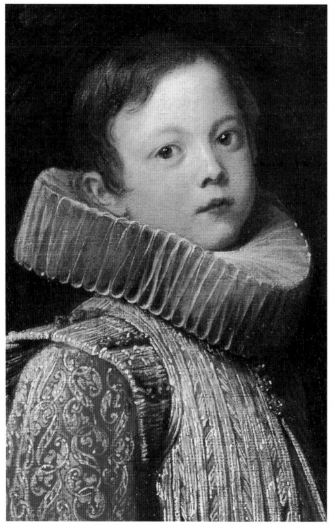

They went to a wise man and asked
His advice. 'I will give you a horse,'
Said the wise man. 'Now go away
And obey your father's will.'

They took the horse and went away.

They now had eighteen horses.
The eldest son took half;
The second son took a third;
The youngest son took a ninth.
And the wise man's horse? They gave it back.

Why did the old man write his will like that?

The Will
IAN SERRAILLIER, 1973

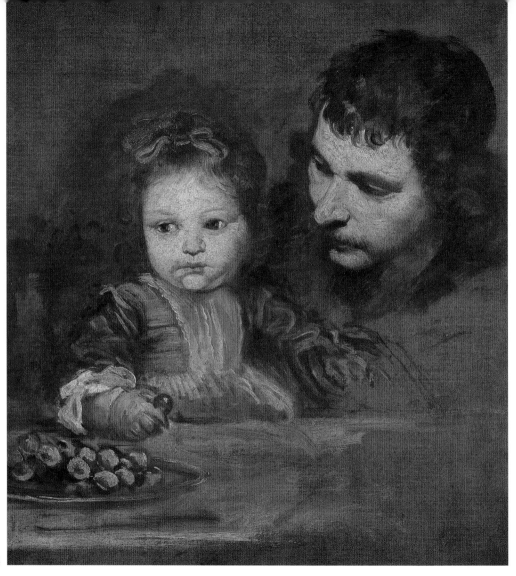

SPANISH SCHOOL
A Man and a Child eating Grapes
probably 19th century

Methinks 'tis pretty sport to hear a child
Rocking a word in mouth yet undefiled;
The tender racket rudely plays the sound,
Which, weakly bandied, cannot back rebound,
And the soft air the softer roof doth kiss,
With a sweet dying and a pretty miss,
Which hears no answer yet from the white rank
Of teeth, not risen from the coral bank.
The alphabet is searched for letters soft,
To try a word before it can be wrought;
And, when it slideth forth, it goes as nice
As when a man doth walk upon the ice.

On a Child Beginning to Talk
THOMAS BASTARD, 1598

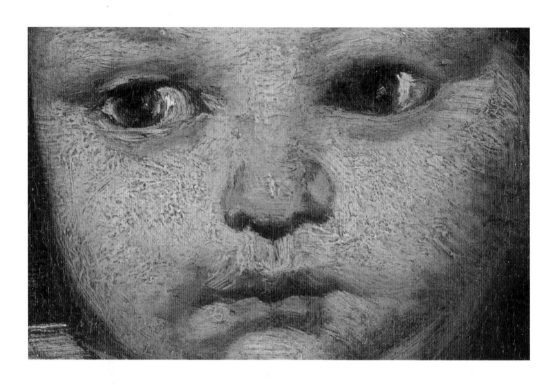

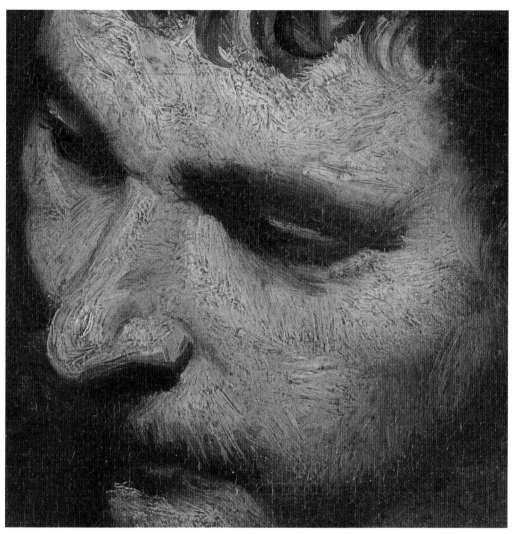

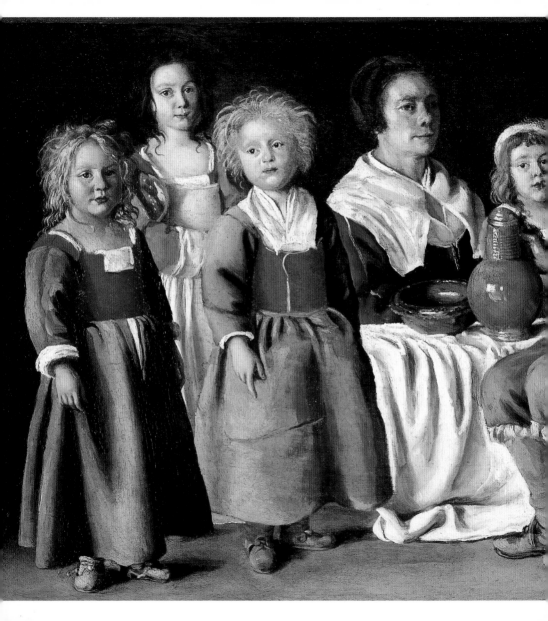

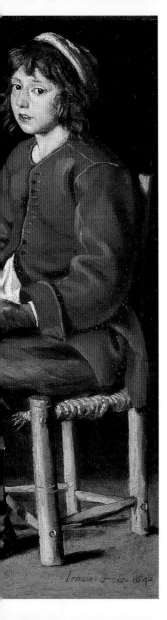

The LE NAIN Brothers
ANTOINE (about 1600–48), LOUIS (about 1603–48)
and MATHIEU (about 1607–77) French
A Woman and Five Children
1642

' 'Tis because of us children, too, isn't it, that you can't get a good lodging?'

'Well—people do object to children sometimes.'

'Then if children make so much trouble, why do people have 'em?'

'Oh—because it is a law of nature.'

'But we don't ask to be born!'

'No indeed.'

'And what makes it worse with me is that you are not my real mother, and you needn't have had me unless you liked. I oughtn't to have come to 'ee—that's the real truth! I troubled 'em in Australia, and I trouble folk here. I wish I hadn't been born!'

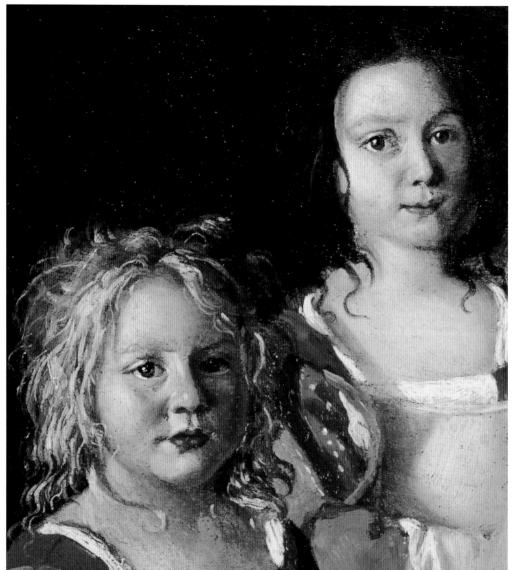

'You couldn't help it, my dear.'

'I think that whenever children be born that are not wanted they should be killed directly, before their souls come to 'em, and not allowed to grow big and walk about!'

Sue did not reply. She was doubtfully pondering how to treat this too reflective child.

She at last concluded that, so far as circumstances permitted, she would be honest and candid with one who entered into her difficulties like an aged friend.

'There is going to be another in our family soon,' she hesitatingly remarked.

'How?'

'There is going to be another baby.'

'What!' The boy jumped up wildly. 'Oh God, mother, you've never a-sent for another; and such trouble with what you've got!'

'Yes, I have, I am sorry to say!' murmured Sue, her eyes glistening with suspended tears.

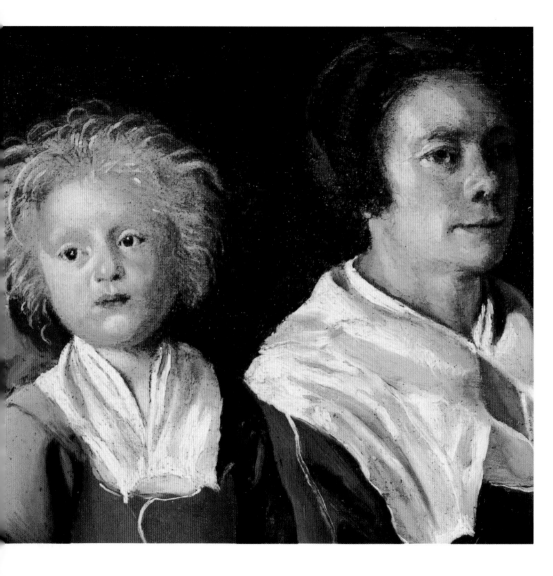

The boy burst out weeping. 'Oh, you don't care, you don't care!' he cried in bitter reproach. 'How *ever* could you, mother be so wicked and cruel as this, when you needn't have done it till we was better off, and father well! To bring us all into *more* trouble! No room for us, and father a-forced to go away, and we turned out tomorrow; and yet you be going to have another of us soon!—'Tis done o'purpose!—'tis—'tis!'

from *Jude the Obscure*
THOMAS HARDY, 1895

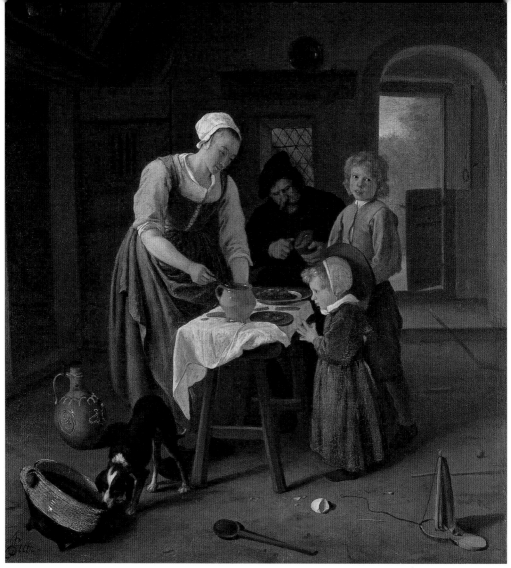

134

JAN STEEN (1625/6–1679) Dutch
A Peasant Family at Meal-time ('Grace before Meat')
about 1665

When the men came home from work they would find the table spread
with a clean whitey-brown cloth, upon which would be knives and two-
pronged steel forks with buckhorn handles. The vegetables would then
be turned out into big yellow crockery dishes and the bacon cut into
dice, with much the largest cube upon Feyther's plate, and the whole
family would sit down to the chief meal of the day. True, it was seldom
that all could find places at the central table; but some of the smaller
children could sit upon stools with the seat of a chair for a table, or on
the doorstep with their plates on their laps.

Good manners prevailed. The children were given their share of the
food, there was no picking and choosing, and they were expected to eat
it in silence. 'Please' and 'Thank you' were permitted, but nothing
more. Father and Mother might talk if they wanted to; but usually they
were content to concentrate upon their enjoyment of the meal. Father
might shovel green peas into his mouth with his knife, Mother might
drink her tea from her saucer, and some of the children might lick their
plates when the food was devoured; but who could eat peas with a two-
pronged fork, or wait for tea to cool after the heat and flurry of cook-
ing, and licking the plates passed as a graceful compliment to Mother's
good dinner. 'Thank God for my good dinner. Thank Father and
Mother. Amen' was the grace used in one family, and it certainly had
the merit of giving credit where credit was due.

from *Lark Rise to Candleford*
FLORA THOMPSON, 1945

135

137

ARTISTS & PAINTINGS

CALRAET, Abraham van
(Attributed to)
A Boy holding a Grey Horse
oil on canvas
61.6 x 66.7 cm, p.72

CHARDIN, Jean-Siméon
The Young Schoolmistress
oil (identified) on canvas
61.6 x 66.7 cm, p.42

CHARLET, Nicolas-Toussaint
Children at a Church Door
oil on canvas
24.1 x 33 cm, p.50

CONSTABLE, John
The Cornfield
oil on canvas
142.9 x 121.9 cm, p.11

DEGAS, Hilaire-Germain-
Edgar
Beach Scene
oil (identified) on paper,
three pieces mounted on
canvas
47 x 82.6 cm, p.96

Young Spartans Exercising
oil on canvas
109.2 x 154.3 cm, p.40

DYCK, Anthony van
The Balbi Children
oil on canvas
219 x 151 cm, p.120

ELSHEIMER, Adam
(After)
*Tobias and the Archangel
Raphael returning with the
Fish*
oil on copper
19.3 x 27.6 cm, p.70

FLEMISH
*Portrait of a Boy holding a
Rose*
oil on canvas
93.4 x 64.8 cm, p.22

GAINSBOROUGH, Thomas
The Painter's Daughters chasing a Butterfly
oil on canvas
113.7 x 104.8 cm, p.2

*The Painter's Daughters
with a Cat*
oil on canvas
75.6 x 62.9 cm, p.81

GHIRLANDAIO, Domenico
(Workshop of)
Portrait of a Girl
tempera on wood, painted
surface
44.1 x 26.3 cm, p.6

GIORGIONE (Imitator of)
*Nymphs and Children in a
Landscape with Shepherds*
oil on wood
46.6 x 87.6 cm, p.18

HALS, Frans
*A Family Group in a
Landscape*
oil on canvas
148.5 x 251 cm, p.116

HOGARTH, William
The Graham Children
oil on canvas
160.5 x 181 cm, p.26

ITALIAN, Neapolitan
*Christ disputing with the
Doctors*
oil on canvas
120 x 161.9 cm, p.47

LANCRET, Nicolas
*The Four Ages of Man:
Childhood*
oil on canvas
33 x 44.5 cm, p.32

LE NAIN BROTHERS,
Antoine, Louis and Mathieu
A Woman and Five Children
oil on canvas
25.5 x 32 cm, p.128

LÉPINE, Stanislas-Victor-Edmond
Nuns and Schoolgirls in the Tuileries Gardens, Paris
oil on wood
15.7 x 23.7 cm, p.56

LOTTO, Lorenzo
Portrait of Giovanni della Volta and his Family (?)
oil (identified) on canvas
114.9 x 139.7 cm, p.102

MAES, Nicolaes
A Woman scraping Parsnips, with a Child standing by her
oil on oak
35.6 x 29.8 cm, p.113

Christ blessing the Children
oil on canvas
206 x 154 cm, p.85

MARIS, Jacob
A Girl feeding a Bird in a Cage
oil on mahogany
32.6 x 20.8 cm, p.93

MOLENAER, Jan
Two Boys and a Girl making Music
oil on canvas
68.3 x 84.5 cm, p.8

NETSCHER, Caspar
A Lady teaching a Child to read, and a Child playing with a Dog
('La Maîtresse d'école')
oil on oak
45.1 x 37 cm, p.65

NOUTS, Michiel
(Attributed to)
A Family Group
oil on canvas
178 x 235 cm, p.104

OOST, Jacob van the Elder
(Attributed to)
Two Boys before an Easel
oil on canvas
56.5 x 58.7 cm, p.88

PERRONNEAU, Jean-Baptiste
A Girl with a Kitten
pastel on paper
59.1 x 49.8 cm, p.76

RENOIR, Pierre-Auguste
The Umbrellas
oil on canvas
180.3 x 114.9 cm, p.37

REYNOLDS, Sir Joshua
Lady Cockburn and her Three Eldest Sons
oil (identified) on canvas
141.6 x 113 cm, p.109

SPANISH SCHOOL
A Man and a Child eating Grapes
oil on canvas
73 x 57.8 cm, p.124

STEEN, Jan
A Peasant Family at Meal-time ('Grace before Meat')
oil on canvas
44.8 x 37.5 cm, p.134

VAILLANT, Wallerant (After)
A Boy seated Drawing
oil on canvas
127 x 99.5 cm, p.60

VIGÉE LE BRUN, Elizabeth Louise
Mademoiselle Brongniart
oil on oak
65.1 x 53.3 cm, p.14

Writers & Works

ALEXANDER, Cecil Frances
(1818–1895), Irish
In the Distance, c.1848,
p.112

ANONYMOUS
Bookworm
English, 10th century, p.64

Pussy
English, c.1830, p.77

*The Hoyden, A Cautionary
Tale*
English, 1811, p.15

Time Like a Morning Hoop
English, 19th century, p.36

BASTARD, Thomas
(1566–1616), English
On a Child beginning to Talk,
1598, p.124

BLAKE, William
(1757–1827), English
Nurse's Song, 1789, p.19

Holy Thursday, 1789, p.50

CARROLL, Lewis
(1832–1898), English
from *Through the Looking
Glass*, 1872, p.43

CARTER, Sydney
(b. 1915), English
Child, 1969, p.108

DICKINSON, Emily
(1830–1886), American
We Talked as Girls Do
c.1862, p.80

HARDY, Thomas
(1840–1928), English
from *Jude the Obscure*, 1895,
p.129

KENNELLY, Brendan
(b. 1936), Irish
Jesus at School, pub. 1970,
p.46

NASH, Ogden
(1902–1971), American
Children's Party, 1936, p.33

NICHOLS, Grace (b. 1950)
English
*Granny Granny Please Comb
my Hair*, pub. 1988, p.96

PATMORE, Coventry
(1823–1896), English
from his diaries, c.1860,
p.105

READING, Peter
(b.1946), English
from *Alma Mater*, 1981, p.61

RICHARDSON, John
(b. 1924), English
from *A Life of Picasso,
Volume 1*, 1991, p.89

SERRAILLIER, Ian
(1912–1994), English
The Will, 1973, p.121

SEWELL, Anna
(1820–1878), English
from *Black Beauty, The
Autobiography of a Horse*
1877, p.73

SPENDER, Stephen
(1909–1995), English
Rough, 1933, p.22

THOMAS, R. S.
(b. 1913), Welsh
Children's Song, 1955,
p.27

THOMPSON, Flora
(1867–1947), English
from *Lark Rise to Candleford*
1945, p.135

Acknowledgments

THOMPSON, Francis
(1859–1907), English
Ex Ore Infantium, 1893,
p.84

TURNER, Elizabeth
(1775?–1846), English
The Canary, c.1807, p.92

UTTLEY, Alison
(1884–1976), English
from *Country Things*, 1946,
p.56

WHITMAN, Walt
(1819–1892), American
from *There was a Child went
Forth*, 1871, p.10

WORDSWORTH, William
(1770–1850), English
*Characteristics of a Child
Three Years Old*, 1815, p.116

The editor and publishers
gratefully acknowledge per-
mission to reprint copyright
material below. Every effort
has been made to contact the
original copyright holders of
the material included. Any
omissions will be rectified in
future editions.

Children's Song by R. S.
Thomas from 'Collected
Poems 1945 –1990' pub-
lished by J. M. Dent by per-
mission of Orion Publishing.

Children's Party by Ogden
Nash by permission of Andre
Deutsch Ltd.

Jesus at School by Brendan
Kennelly from 'Love of
Ireland' published by Mercier
Press by permission of the
author and publisher.

excerpt from *Country Things*
by Alison Uttley published by
Faber & Faber Ltd, by per-
mission of the publisher.

Alma Mater by Peter
Reading from 'Tom
O'Bedlam Beauties' pub-
lished by Martin, Secker &
Warburg by permission of
the author and publisher.

*Granny Granny Please Comb
My Hair* by Grace Nichols
from 'Come On Into My
Tropical Garden' reproduced
with permission of Curtis
Brown Ltd, London, on
behalf of Grace Nichols.
Copyright © Grace Nichols
1988.

Child by Sydney Carter by
permission of Steiner & Bell
Ltd.

The Will by Ian Serraillier
from 'I'll Tell You a Tale'
published by Puffin (1973)
by permission of Anne
Serraillier, widow of the
author.

excerpt from *Lark Rise to
Candleford* by Flora
Thompson by permission of
Oxford University Press.

Title page:
Thomas Gainsborough, detail of *The Painter's Daughters chasing a Butterfly*, about 1756
Play title page:
Jan Molenaer: *Two Boys and a Girl making Music*, 1629
School title page:
Hilaire-Germain-Edgar Degas: *Young Spartans Exercising*, 1860
Friends title page: After Adam Elsheimer: *Tobias and the Archangel Raphael returning with the Fish*, mid-17th century
Home title page:
Lorenzo Lotto: *Portrait of Giovanni della Volta and his Family* (?), 1547